# CATSTROLOGY

# CATSTROLOGY

## UNLOCK THE SECRETS OF THE STARS WITH CATS

LUNA MALCOLM

GRAND CENTRAL
PUBLISHING

New York   Boston

Any resemblance in these astrological readings to actual persons, living or dead, is purely coincidental. Also, it's astrology, of course it's accurate.

Grand Central Publishing
Hachette Book Group
1290 Avenue of the Americas, New York, NY 10104
grandcentralpublishing.com
twitter.com/grandcentralpub

Originally published in Great Britain by Trapeze, an imprint of the
Orion Publishing Group Ltd, in October 2019
First US edition: October 2020

Grand Central Publishing is a division of Hachette Book Group, Inc. The Grand Central Publishing name and logo is a trademark of Hachette Book Group, Inc.

The publisher is not responsible for websites (or their content) that are not owned by the publisher.

Library of Congress Control Number: 2020935786

ISBNs: 978-1-5387-3712-5 (hardcover), 978-1-5387-3711-8 (ebook)

Printed in China

1010

10  9  8  7  6  5  4  3  2  1

# FOREWORD

The universe is a vast and confusing place. Astrology is just one of the countless methods that people have used for centuries to decipher the secrets of themselves and their lives.

Now, for the first time, in this new series of books, you can unite the principles of astrology with your love of cats and dogs. We are all affected by the stars and planets as the earth hurtles through this cold and dark expanse – why not involve our furry friends too?

*Luna Malcolm*

# THE SUN SIGNS
## AT THEIR BEST
## AND WORST

# ARIES
(21 March – 19 April)

At their best
courageous,
determined, bold,
enthusiastic,
optimistic, honest,
passionate

At their worst
impatient, short-
fused, impulsive,
world's biggest grump

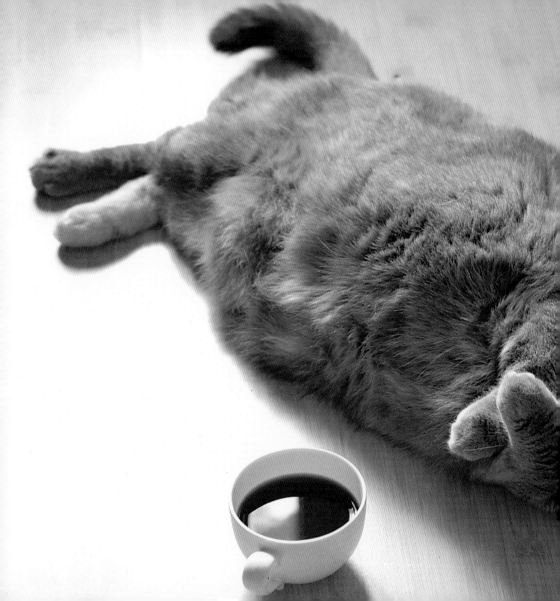

# TAURUS
(20 April – 20 May)

At their best
reliable, patient,
practical, devoted,
responsible, aesthete

At their worst
obstinate,
possessive,
uncompromising,
eyes bigger than
stomach

# GEMINI
### (21 May – 20 June)

At their best
affectionate,
curious, adaptable,
great communicator,
quick learner

At their worst
inconsistent,
fidgety, gossipy,
in possession of an
internal evil twin

# CANCER
(21 June – 22 July)

At their best
tenacious, vivid imagination, intuitive, persuasive,
in touch with their feelings

At their worst
suspicious, manipulative, insecure,
huge crybaby

# LEO
(23 July – 22 August)

At their best
creative, generous, warm-hearted, cheerful,
life of the party

At their worst
self-centred, inflexible, vain, incurable drama queen

# VIRGO
(23 August – 22 September)

At their best
loyal, analytical, kind,
hard-working, practical

At their worst
shy, worrywart, overly critical,
all work and no play

# LIBRA
(23 September – 22 October)

At their best
cooperative,
diplomatic, gracious,
fair-minded, social

At their worst
avoids confrontations,
unforgiving,
self-pitying, hopeless
at making decisions

# SCORPIO
(23 October – 21 November)

At their best
resourceful, brave, passionate,
steadfast, a true friend

At their worst
distrusting, jealous, secretive,
epic levels of petty

# SAGITTARIUS
### (22 November – 21 December)

**At their best**
generous, idealistic,
adventurous, great sense
of humour

**At their worst**
promises more than
can deliver, itchy feet,
impatient, absolutely no
filter

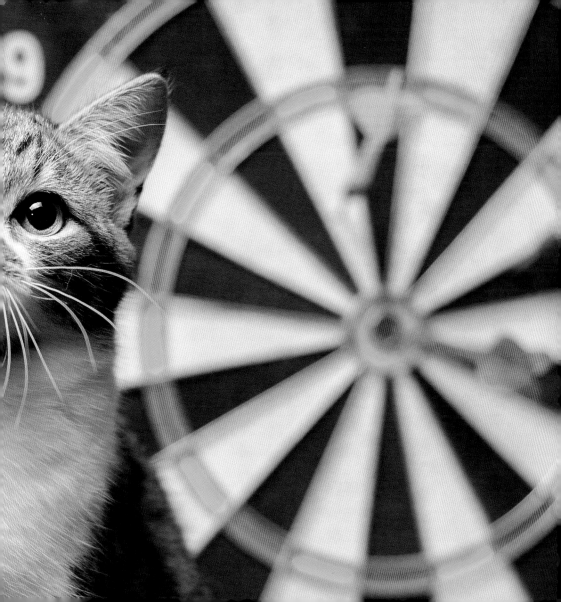

# CAPRICORN
(22 December – 19 January)

At their best
responsible, disciplined, organised,
cool as a cucumber

At their worst
know-it-all, judgemental,
sarcastic, glass is half empty

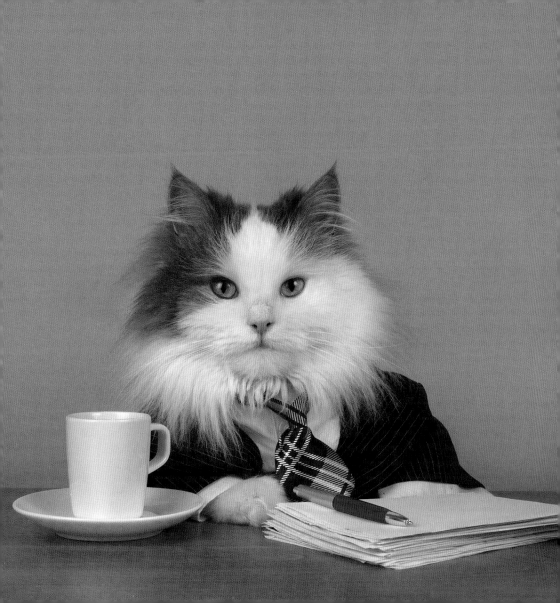

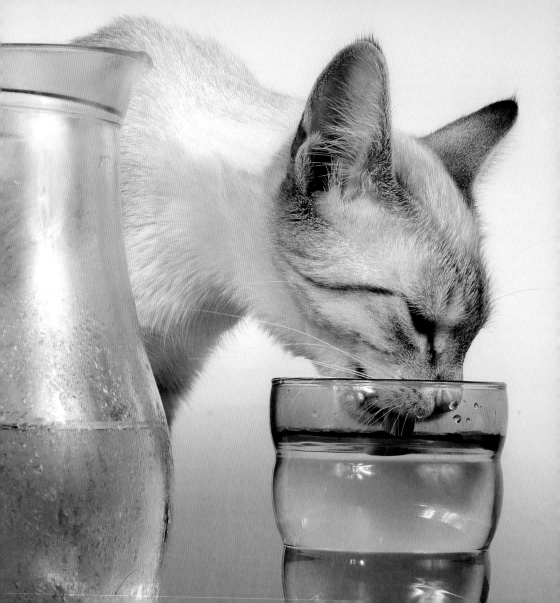

# AQUARIUS
(20 January – 18 February)

At their best
progressive, original, independent,
humanitarian

At their worst
flees from emotional expression,
temperamental, uncompromising, aloof

# PISCES
(19 February – 20 March)

At their best
compassionate,
artistic, intuitive,
gentle, wise

At their worst
overly trusting, sad,
desires to escape
reality, enjoys being
a martyr

# WHAT TO KNOW BEFORE INVITING EACH SIGN TO A PARTY

Will scratch the furniture
Aries, Sagittarius

Will spend most of the evening in a corner eating the snacks
Taurus, Cancer

Will say hello to everyone and then bounce off somewhere else
Gemini, Aquarius

Will trap someone in an intense conversation for hours
Scorpio, Libra, Pisces, Capricorn
(all with very different kinds of conversations)

Will spend ages in the bathroom
Leo (taking selfies), Virgo (trying your beauty products)

# CHOOSE YOUR WEAPON

Aries: the ultimate cutting remark

Taurus: ancient, bottomless and boiling rage

Gemini: extraction and exploitation of your deepest secrets

Cancer: round-the-world guilt-tripping

Leo: the last word

Virgo: Medusa-level resting bitch face

Libra: unassailable fence-sitting

Scorpio: an unliftable grudge

Sagittarius: honesty that crushes with the force of a black hole

Capricorn: gale-force aggressive sighs

Aquarius: endless interruption

Pisces: making themselves the victim

# PLANETARY POSITIONS

You'll already know your sun sign – either from the previous section or you knew it before – which forms the foundation to your zodiac personality. But astrology is onion-like in its layers of complexity, and there is a whole solar system of planets to consider:

Your ascendant or rising sign and moon sign are the two big supporting signs to your personality.

The next most important planets to consider in your chart are the placements of the solar system's inner planets: Mercury, Venus and Mars. Also known as the personal planets, they rule a collection of traits that might explain why you're louder, more forgiving or more sarcastic than your friends of the same sign.

The outer planets – Jupiter, Saturn, Uranus, Neptune and Pluto – move around us much more slowly, so they can stay in a sign for many years. As a result, they shape the bigger trends in your life. Uranus, Neptune and Pluto orbit the sun so slowly that they're said to shape entire generations. (Yes, astrologers still consider Pluto a planet. It's OK, Pluto, you are among friends here.)

# ASCENDANT

Your ascendant or 'rising' sign is the one that was on the eastern horizon when you were born, so in the same way that the sun appears to move across the sky each day, ascendant signs change every two hours and yours will depend on the time and place of your birth. It corresponds to the 'mask' you wear, how you initially come across with people. Do you give off weird vibes on first encounter, no matter how hard you try? Blame your rising sign.

# MOON

Your moon sign is also determined by the finer details of your birth as it changes every couple of days. It has the greatest influence on your personality after your sun sign because it corresponds to what lies beneath the surface: your deep emotions and how you are when you are most comfortable. Naturally, it is also the ruling planet of Cancer, the biggest emo of the zodiac.

# INNER PLANETS

In Roman mythology, Mercury is the messenger of the gods, so the sign that occupies Mercury in your chart will give you an insight into how you communicate, express your thoughts and handle yourself under pressure. It is Gemini and Virgo's ruling planet – lucky Mercury gets two signs to rule! Shame they can both be terribly critical and love a gossip.

Venus is, naturally, the planet of love: it is sensual Taurus and flirty Libra's ruling planet. Your Venus sign isn't just about romantic love, though. The sign that occupies this position in your chart also informs you about how you show affection to others, and what you find attractive or admire in other people.

Your Mars sign, as you'd expect of the warlike god with the same name, relates to conflict and power. It reveals how you respond to confrontation, how you express your anger, and your attitude to sex. Unsurprisingly it is the ruling planet of Aries, the sign with heaps of bravery.

# OUTER PLANETS

The least slow-moving of the outer planets, Jupiter (the ruling planet of jovial Sagittarius) and Saturn (the ruling planet of Capricorn, the grown-up of the zodiac) form two sides of a coin that makes them the 'social planets'. While Jupiter brings optimism and informs what will nourish your personal growth, Saturn is all about rules, self-discipline and learning – and what you might struggle with most.

Uranus, the first of the three generation-ruling planets, rules the visionary Aquarius – your Uranus sign reveals how your generation might want to shake up the status quo.

No other planet but the one named after the god of the sea, Neptune, will do for Pisces! Naturally, it informs almost a whole generation's imagination and dreams, staying in each sign for around double the amount of time Uranus does.

Last but not least, the dark and mysterious Pluto can stay in a sign for up to thirty years, a long reign for a snubbed planet (how appropriate for Scorpio, who is ruled by it!). Your Pluto placement shows the attitudes to power and control that your whole generation share.

# THE SIGNS AS TYPICAL CAT BEHAVIOUR

Aries: runs circuits around the house at 4am

Taurus: only eats the expensive food, in only one or two of the available flavours

Gemini: cannot decide whether to be inside or outside but needs you to open the door to decide

Cancer: meows until you get into bed and they can snooze at the end of it

Leo: sits in front of your screen

Virgo: plays with a toy until they miss it and then suddenly starts grooming

Libra: rubs themselves round your legs in a figure-of-eight motion

Scorpio: accepts belly rubs until they decide – with no notice – to bite you

Sagittarius: watches birds outside and chirrups

Capricorn: climbs to the highest spot in the room to survey everyone below

Aquarius: lies on a stair and refuses to move

Pisces: stares at reflections on the walls

# THE SEVEN DEADLY SINS

Greed
Leo

Gluttony
Taurus

Envy
Gemini, Virgo

Lust
Libra, Pisces

Sloth
Cancer

Wrath
Aries, Capricorn, Scorpio

Pride
Sagittarius, Aquarius

# ELEMENTS

There are four elements in the zodiac, with three of each of the signs belonging to a certain element.

# FIRE

Aries, Leo and Sagittarius all share similar fiery qualities: they might have a few problems with impulsiveness and coming on too strong, but they are also dynamic, straightforward and will liven up the dullest gatherings.

# EARTH

Taurus, Virgo and Capricorn are the nurturing and grounded earth signs. Practical and loyal to the last, earth signs can get a bit caught up in the material world – but hey, that also means they buy the best gifts.

# AIR

Hold on tight! The winds of Gemini, Libra and Aquarius are here to shake things up. Air signs are all about ideas and action, and although they might put you down as quickly as they swept you up, they have unrivalled curious minds and the best conversation.

# WATER

The water signs, Cancer, Scorpio and Pisces, will immerse you in love. Intuitive and sensitive, these signs make the sweetest friends – although be careful. Just like the sea, sometimes you don't know when you're out of your depth with them until it's too late!

# SHORTCUTS TO THEIR AFFECTIONS

Buy them something
Taurus, Leo

Take them on an adventure
Gemini, Sagittarius, Aquarius

Let them win the argument
Aries, Virgo, Capricorn

Share something with them
Cancer, Libra, Pisces

There are none
Scorpio

# THE SIGNS AS WEATHER PHENOMENA

Aries: spring heatwave

Taurus: unrelenting humidity

Gemini: small tornado that picks up bits

Cancer: warm sunshine between rainclouds

Leo: 'sun's out, guns out' weather

Virgo: lightning storm with a little rain

Libra: the kind of cold that makes autumn leaves crispy

Scorpio: overnight snowdrift

Sagittarius: flash flood

Capricorn: a warm night you can sit outside

Aquarius: cold snap

Pisces: rainbow

# MODALITIES

As well as the elements, each of the zodiac signs has one of three modalities. It helps to think of these as like the changing seasons: cardinal begins a cycle, fixed sustains it, and mutable brings about change.

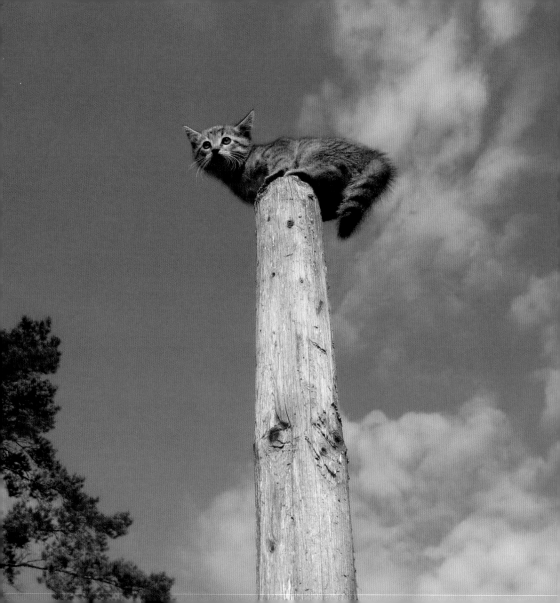

# CARDINAL

The cardinal signs are Aries, Capricorn, Libra and Cancer.

They're self-aware, love to take the lead and have tons of ideas. Whatever they might lack in terms of seeing things through to completion, they make up for in how much they inspire others.

# FIXED

The fixed signs are Taurus, Leo, Scorpio and Aquarius.

They tend to enjoy routine and dislike any unexpected disruption, and they can be stubborn and controlling. But when this strength is channelled for good, fixed signs are loyal to a fault, and the greatest at getting stuff done.

# MUTABLE

The mutable signs are Gemini, Virgo, Sagittarius and Pisces.

They are adaptable and flexible and take great pleasure in being quick learners. While this can sometimes make them seem like little of their lives is in order, they are really the editors of the zodiac: masters of adding the perfect finishing touch.

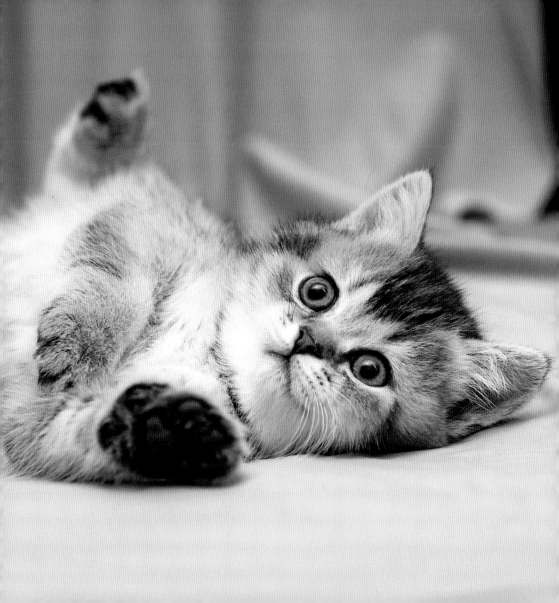

# LOOKING FOR LOVE IN
# ALL THE WRONG PLACES

The signs most likely to . . .

Hold on to their feelings for an ex
Taurus, Cancer

Reveal their innermost desires to someone they've only just met
Gemini, Sagittarius

Respond to an inappropriate late-night message by immediately
going to the unsuitable person's house
Aries, Capricorn, Scorpio

Interpret unambiguous signs of dislike as 'playing hard-to-get'
Leo, Aquarius

Schedule two dates on the same night
Libra (accidentally), Virgo (on purpose), Pisces (just to see what happens)

# DOESN'T LEAVE THE HOUSE WITHOUT

Aries: (prefers to not carry anything)

Taurus: emergency snacks

Gemini: statement footwear

Cancer: a comfy sweater

Leo: a hairbrush

Virgo: a good book

Libra: somewhere to go to

Scorpio: wearing a huge pair of headphones

Sagittarius: a packet of sparklers

Capricorn: a corkscrew

Aquarius: a foldaway placard

Pisces: a clear quartz wand

# SISTER SIGNS

In the spirit of the old saying 'opposites attract', sister signs are those that sit opposite each other on the zodiac wheel. These pairings should make you feel complete. . . they might drive you crazy. But when they team up, they bring out the best (and sometimes the worst) in each other.

# ARIES & LIBRA

Perhaps the most contrasting sister signs of the zodiac: bold and fiery Aries loves to lead, but they could benefit from the consideration that harmony-seeking Libra sometimes takes too much of before acting out their decisions! But Aries has just as much to give Libra too, and could instil some firmness in their air sign sister and help them stand up for themselves a little more.

*Aries and Libra testing out their latest, finely crafted inside joke on you*

# TAURUS & SCORPIO

This pair of sister signs are the most steadfast of the zodiac. Taurus and Scorpio will always follow their own beat, but they'll also always stick by you. Just watch that they don't get too into you. Scorpio could teach Taurus a thing or two about the benefits of change, while Taurus can give Scorpio stability – but both can hold a passionate obsession like nobody else in the universe!

*Taurus and Scorpio bonding over their longest-held grudges*

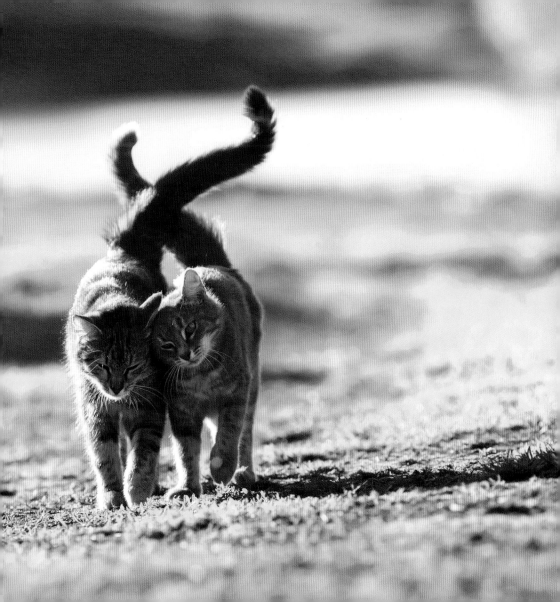

# GEMINI & SAGITTARIUS

The curious minds of the zodiac meet in the sister signs of Gemini and Sagittarius! Gemini's quest for knowledge leads them to making unlikely friendships and trawling the darkest corners of the internet; Sagittarius has permanently itchy feet that take them across the world in search of more things to learn. Gemini can teach Sagittarius the benefits of a judicious lie in their black-and-white world of honesty.

*Gemini and Sagittarius on the hunt for the latest trouble
they can get themselves into for their own amusement*

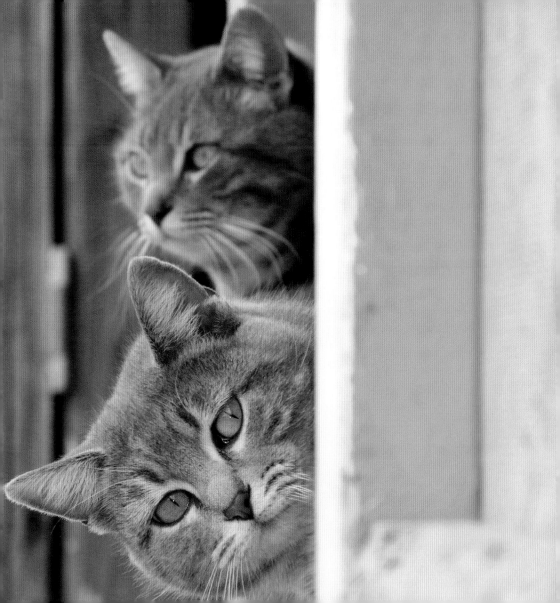

# CANCER & CAPRICORN

This pairing unites the nurturers of the zodiac, albeit in ways that are pretty much diametrically opposed... Cancer is the shoulder for you to cry on, the friend who will take care of you when you're sick. Capricorn will help you with career advice and financial matters – but will probably also give you some of that tough love you need in the form of unvarnished truth. Cancer might be one of the only signs that can get Capricorn to loosen up in their emotions with.

---

*Capricorn accepting the smushy love from Cancer*
*that they know, deep down, is good for them*

# LEO & AQUARIUS

These sister signs are the biggest suckers for people and their praise. But luckily, they go about it in different ways (thankfully, because you do not want to steal either of their spotlight): Leo wants to be seen to be doing things and to be a great leader, while Aquarius cares more about the bigger picture and praise for the ideas they bring. Leo's warmth brings out the aloof Aquarius, and Aquarius brings the fun that Leo will never get bored with.

*Leo and Aquarius heading home at the end of an impromptu 'big night out' much later – and much more worse for wear – than expected*

# VIRGO & PISCES

In their own ways, Virgo and Pisces are the most resilient pairing of the sister signs. They balance each other's experience of reality perfectly, too: Virgo's sense of practicality and structure gives dreamy Pisces a bit of grounding, while Pisces' selfless love can warm up Virgo's sometimes cold outlook.

*Virgo showing Pisces how the internet can be used to organise your finances and book holidays as well as watching documentaries about the paranormal*

# DREAM JOB

Aries: an even more successful singer than Leo

Taurus: luxury bed tester

Gemini: investigative journalist with a celeb gossip blog

Cancer: emotional support animal

Leo: model–performer–influencer

Virgo: marine biologist

Libra: street-style photographer and gallery owner

Scorpio: mortician

Sagittarius: musical philosopher (who is lowkey better than Leo and Aries)

Capricorn: private tutor with a great pension plan

Aquarius: humanitarian

Pisces: fortune cookie fortune writer

# TYPES OF HUMOUR

Irony
**Gemini, Scorpio**

Dad jokes
**Taurus, Leo, Sagittarius**

Witty wordplay
**Virgo, Libra, Capricorn**

Self-deprecation
**Cancer, Pisces**

Toilet humour
**Aries**

Surreal
**Aquarius**

# WHICH CAT BREED IS BEST FOR YOUR SUN SIGN?

# ARIES

Bold and fiery Aries would be well-suited to an equally feisty feline partner – how about the challenge of an exotic crossbreed like a Savannah cat? You're probably one of the few signs brave enough to take on the challenge.

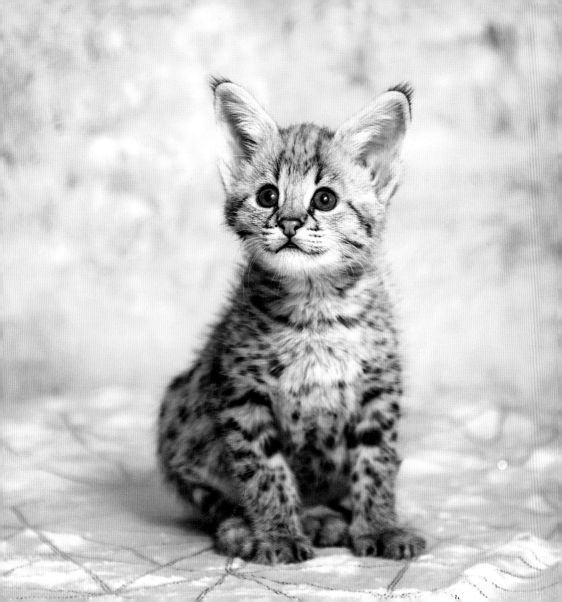

# TAURUS

The original couch potato, Taureans will get along well with any 'indoor cat'. But your perfect match? A really soft beauty like a Birman, which benefits from a lower maintenance coat than other long-haired cats, for when you're too lazy to brush them.

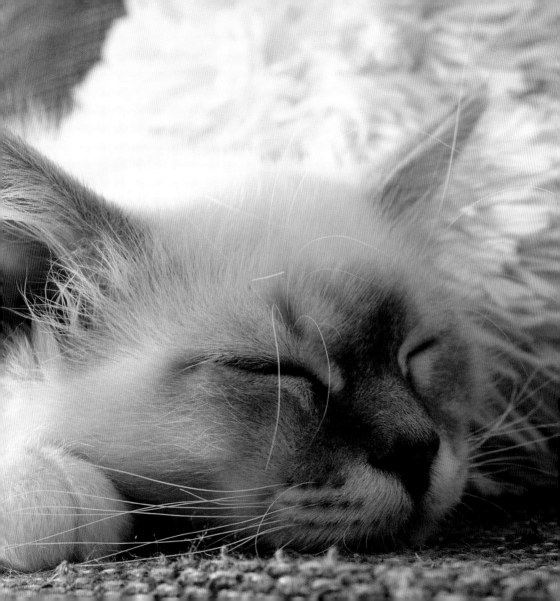

# GEMINI

You love a chat and perhaps unfairly get judged as fickle and changeable – but that's OK, Gemini, because you'll get along perfectly with a slinky Siamese, who's been given an equally shady name in pop culture but really has the warmest of hearts.

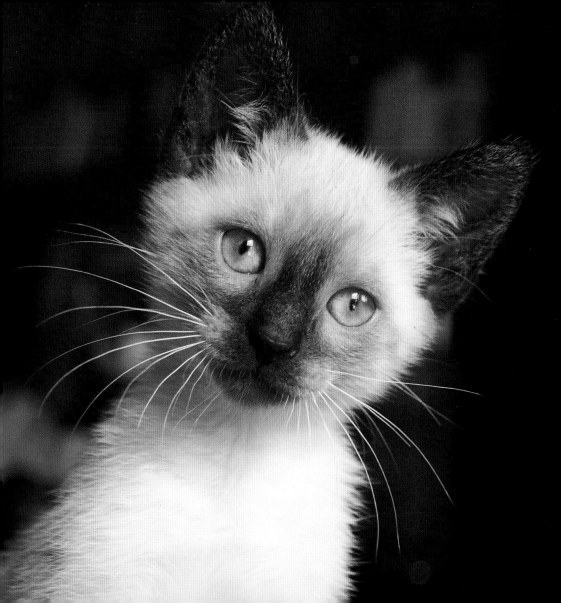

# CANCER

The big softies of the zodiac, Cancer is ideally suited to a breed like the needy Burmese. These cuties are more like puppies than cats, and will give you all the love you could ever wish for.

# LEO

The life of the party but with a secret soft (sometimes too soft) side, Leo's best feline match lies with the majestic Norwegian Forest Cat – plus you can get one that looks just like a lion. Stylish!

# VIRGO

Your love of organisation and tendency to be a little neurotic matches most cat personalities pretty well, Virgo! A great companion for you would be the shy-but-steadfast Russian Blue, who forms the strongest of bonds with their favourite humans.

# LIBRA

If you can manage to decide on a breed, Libra, the sociable crowd-pleaser Scottish Fold is your perfect match! This little cat will give you the companionship you adore. You'll love each other for ever, and you'll be able to set up the cutest social media account for them.

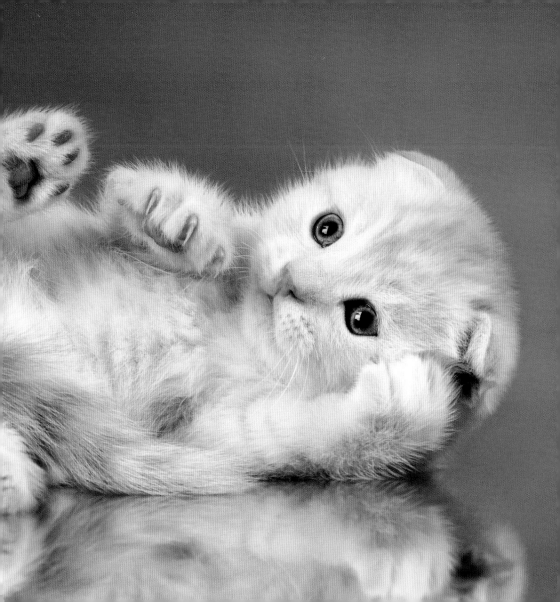

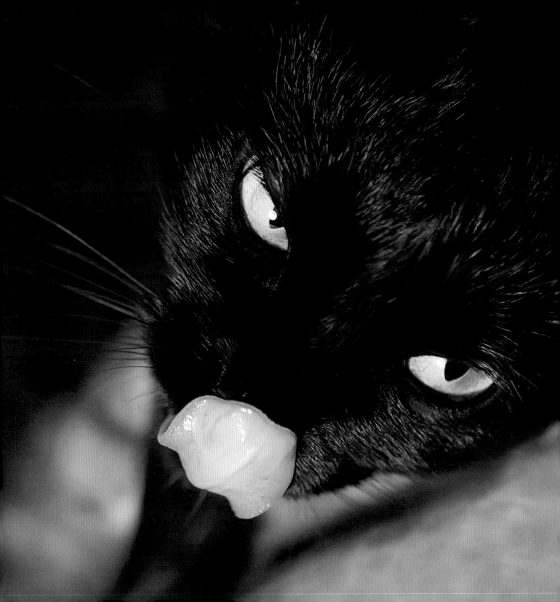

# SCORPIO

You won't be able to resist the mystery of a black moggy, particularly if they're a rescue – you can have all the fun of creeping out your friends with lurid stories of where your new pal came from . . .

# SAGITTARIUS

Gregarious, adventurous and a lover of exploring the new, Sagittarians will find their perfect feline partner in the smart and endlessly energetic form of the Bengal. Watch out for those claws, though!

# CAPRICORN

Why you're consulting this wildly unresearched book for your perfect cat, I don't know. That aside, for sensible Capricorn, the well-behaved and independent British Shorthair could be just the cat you're looking for.

# AQUARIUS

For free-thinking Aquarius, the aloof nature some people dislike in cats is a huge win. For maximum insurance against neediness you should of course go for a semi-feral barn cat, but if you'd like some original company, a hairless Sphynx will be your best pal.

# PISCES

With one foot in a more intuitive world than the rest of us, Pisces will find the best companionship with the sweet – and slightly otherwise – Ragdoll. They're also the best cuddle partners after a long day of having to deal with other people's hopeless tunnel vision.

# AT REST

The signs most likely to do the following to relax . . .

Binge
Taurus, Capricorn

Spoon
Cancer, Leo, Pisces

Exercise
Virgo, Libra, Sagittarius

Party
Aries, Aquarius

Fall into an internet rabbit hole
Gemini, Scorpio

# BEST AT IGNORING . . .

Aries: the need to use an inside voice
Taurus: proof that they were wrong
Gemini: other people's messy emotions
Cancer: the fact they haven't left the house in days
Leo: helpful advice from someone who went through something similar
Virgo: constructive criticism
Libra: unanswered texts
Scorpio: their control issues
Sagittarius: their overdraft
Capricorn: people who ask for hugs
Aquarius: rational explanations for things
Pisces: overdue projects

Advice for Aries

sometimes the best way to hunt is by slowing down and watching

Advice for Taurus
let other people make the choices (even if they are wrong)

Advice for Gemini

there is nothing like a good cuddle

being straightforward with others will hurt them less than you worry about

Advice for Leo

even when you don't get praised, you're still doing a great job

Advice for Virgo

overthinking and dwelling on something is not problem-solving

## Advice for Libra

let people come and pay attention to you, for once

Advice for Scorpio

a projection of heartlessness doesn't actually fool that many people

Advice for Sagittarius

it's impossible to live without letting a few things pass you by – let them

it's never too late to speak up about something

try opening up about your feelings

Advice for Pisces
if it feels wrong, it probably is

# IMAGE CREDITS

Shutterstock

Shutterstock

Shutterstock

Shutterstock

Shutterstock

Shutterstock

Shutterstock

Shutterstock

Shutterstock

Shutterstock

Shutterstock

Shutterstock

Shutterstock

Shutterstock

Natasha Vouckelatou

Shutterstock

Shutterstock

Jenny Lord (Winnie)

Natasha Vouckelatou
(Herbert)

Shutterstock

Shutterstock

Shutterstock

Shutterstock

Shutterstock

Shutterstock

Shutterstock

Shutterstock

Shutterstock

Shutterstock

Shutterstock

Shutterstock

Shutterstock

Anna Valentine
(Smokey Joe)

Shutterstock

Shutterstock

Shutterstock

Shutterstock

Shutterstock

Shutterstock

Shutterstock

Shutterstock

Shutterstock

Shutterstock

Shutterstock

Shutterstock

Shutterstock

Shutterstock

Shutterstock

Shutterstock

Shutterstock

Shutterstock

Shutterstock

Shutterstock

Shutterstock

Shutterstock

Shutterstock

Shutterstock

Shutterstock

Shutterstock

Shutterstock

Shutterstock

Shutterstock

Shutterstock

Shutterstock

Shutterstock

Shutterstock

Shutterstock